W9-DFU-563

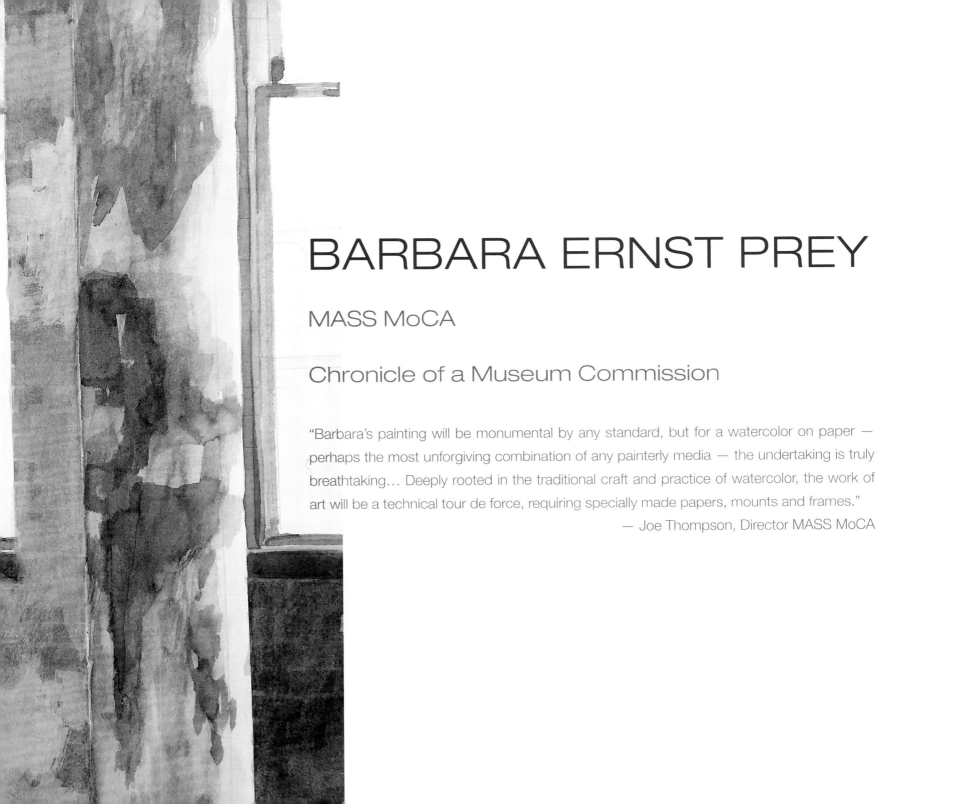

BARBARA ERNST PREY

MASS MoCA

Chronicle of a Museum Commission

"Barbara's painting will be monumental by any standard, but for a watercolor on paper — perhaps the most unforgiving combination of any painterly media — the undertaking is truly breathtaking… Deeply rooted in the traditional craft and practice of watercolor, the work of art will be a technical tour de force, requiring specially made papers, mounts and frames."

— Joe Thompson, Director MASS MoCA

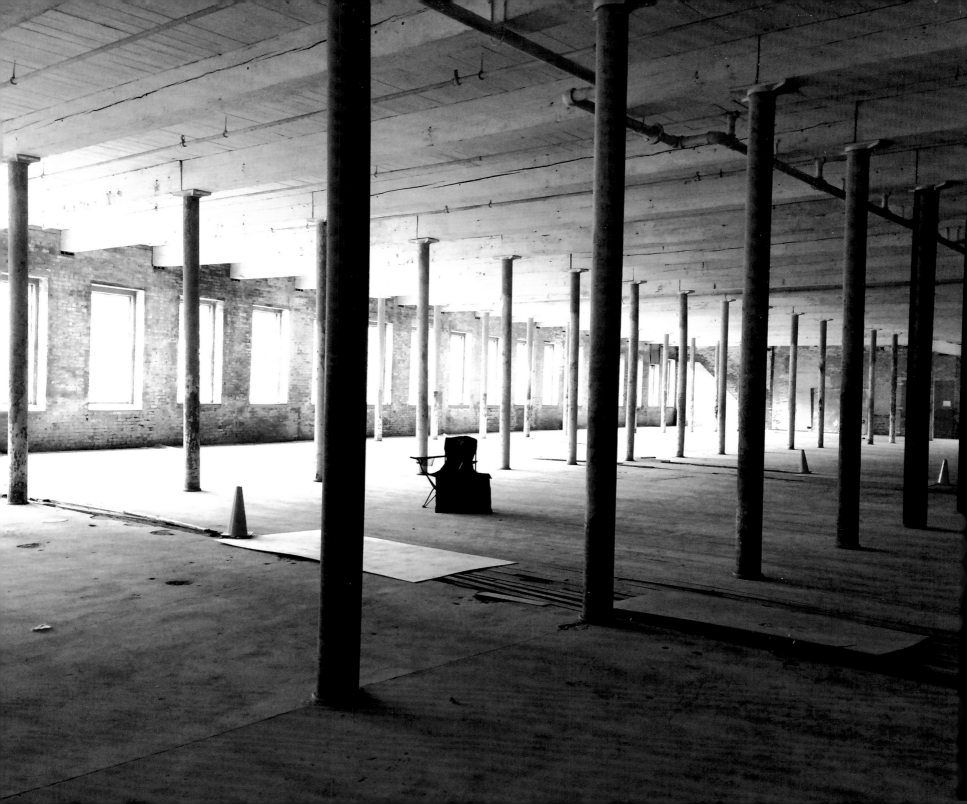

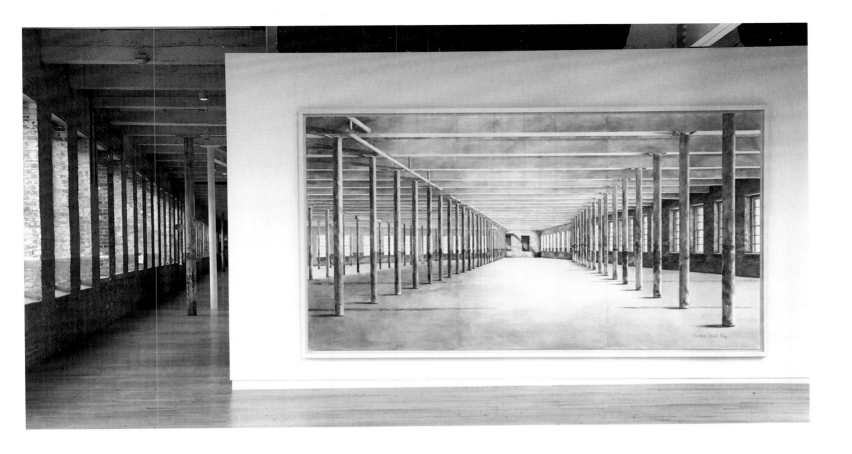

In November 2016, Prey was commissioned by the Massachusetts Museum of Contemporary Art (MASS MoCA) to paint a vast new watercolor for Building 6, an addition of over 120,000 square feet of exhibition space, which opened Memorial Day 2017. Her painting would depict part of the interior of Building 6 in its raw, un-renovated state as a historic mill, before the space transformed into long-term exhibition galleries for the Robert Rauschenberg Foundation, Jenny Holzer, James Turrell, Laurie Anderson, Louise Bourgeoise, Prey herself, and others. With the Building 6 addition MASS MoCA became the largest contemporary art museum in the country. Fittingly, Prey's completed portrait of Building 6's interior is the world's largest watercolor painting.

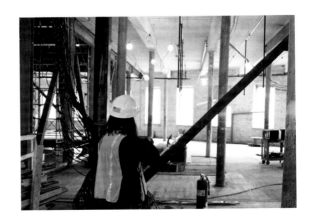

Interior portrait of the old mill as renovation begins.

ARCHITECTURE AND MEMORY

The history of MASS MoCA's space and architecture is characterized by over 200 years of change. The 16 acres of grounds originally housed various small-scale industries and were transformed into a textile-printing mill in the 1860s by Arnold Print Works. Most of the present-day buildings were constructed in the period between 1860 and 1890. From 1942-1985, the site was the home of Sprague Electric, which largely left the exterior of the buildings untouched. In 1986, a year after Sprague Electric closed its doors, the idea for MASS MoCA was born – and the museum officially opened its doors to the public a little over a decade later in 1999.

> "Sprague Electric was still in North Adams when I attended Williams College and I had the unique experience with this commission to spend time in a space whose changes I've been able to personally witness. I've watched as the area of the building my painting depicts has slowly disappeared and been transformed, the floor is cleaned up, the walls are put in and some of the columns are missing. There are still parts of the original space which have provided references for what was there prior, a net to catch my memory and impressions as I begin the process of creating the painting."

Before construction on Building 6 commenced Prey spent time over the course of several months in the fall, winter, and early spring drawing inside the building and figuring out the specific view she would paint, the perspective that would be most evocative of the history of the space and best convey the feel of the interior's unique architecture.

> "I had to dress in layers because it was cold there with no heat, but it was a great time to draw and observe the space uninterrupted. The process was similar to how I approached my NASA commission celebrating the International Space Station in 2003, where for half a year I worked with the director of the project and undertook my own independent research in order to have an informed way of seeing the subject and its context, learning how to most fully bring that to life in my work. Coincidentally, Sprague Electric, the last tenant of the old mill space, was one of the makers of ceramic tiles for NASA shuttle flights."

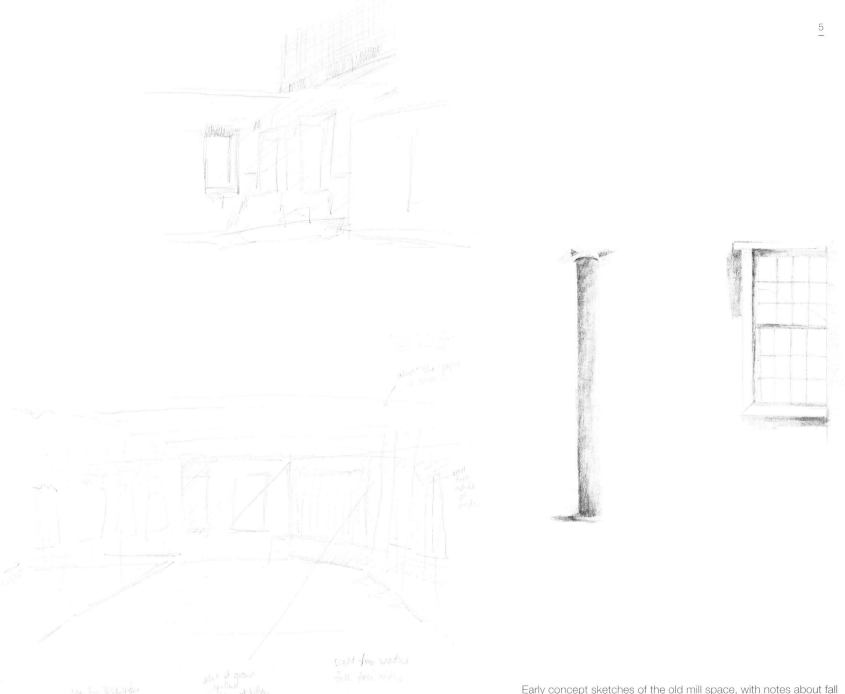

Early concept sketches of the old mill space, with notes about fall of light and shadow colors.

STUDIES

Prey began with pencil studies to be sure that the architecture was accurate and to work out the light and darks of the interior space, as well as the overall composition. The final size of the piece is so enormous that it was important to solve the problems that might arise at the start.

"I did artwork for *The New Yorker* for ten years and my drawings then had architectural details with whimsical, energy-filled lines. The MASS MoCA space is defined by a different type of line, it is a strong architectural space layered with history and a connection to the North Adams community. The process brought me back to my studies with Lane Faison as a student at Williams College. I spent many afternoons with Lane pouring over architectural drawings and interior photos to examine space while working on my senior honors thesis. Interestingly, it was Lane who first brought me to see MASS MoCA. He wanted me to see the space, he was so excited about it. I remember going through the building with him before it opened; so coming back now to paint a monumental portrait of the interior has a very personal connection for me."

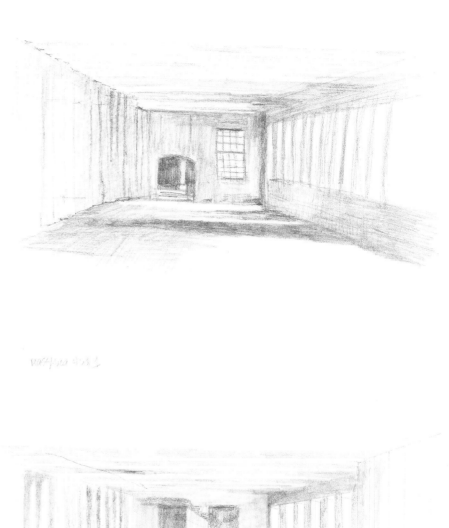

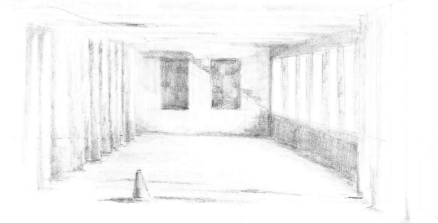

Early studies.

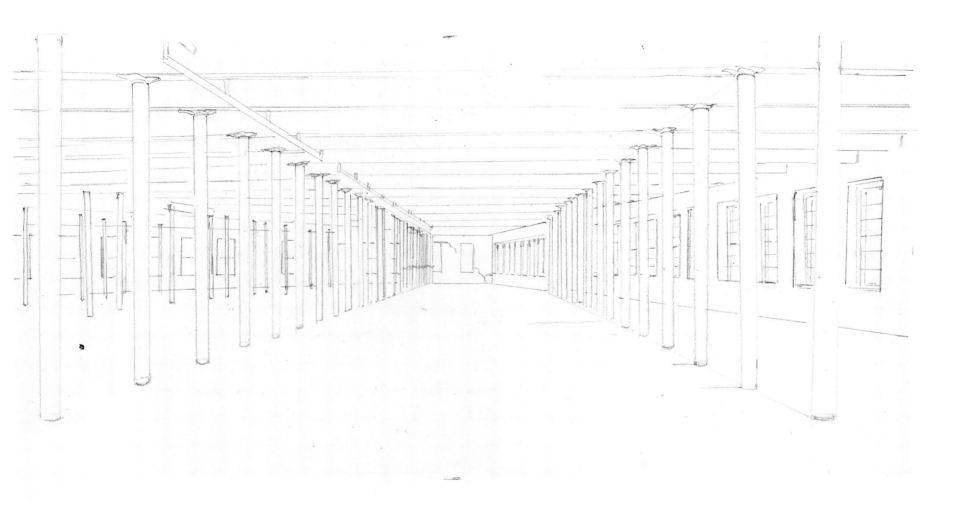

First pencil drawing. Establishing the outline of the space and column placement.

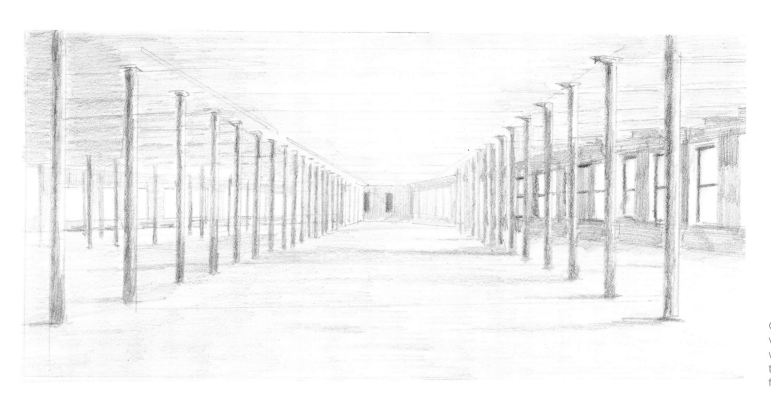

Graphite drawing to get the values down. Trying out different weights for the shadows on the floor and the light coming in from the windows.

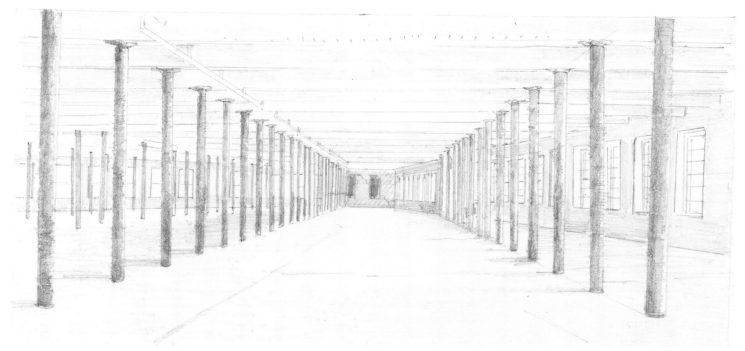

Added finishing details to windows. More defined shadows on the supporting columns and lighter tone to the foreground.

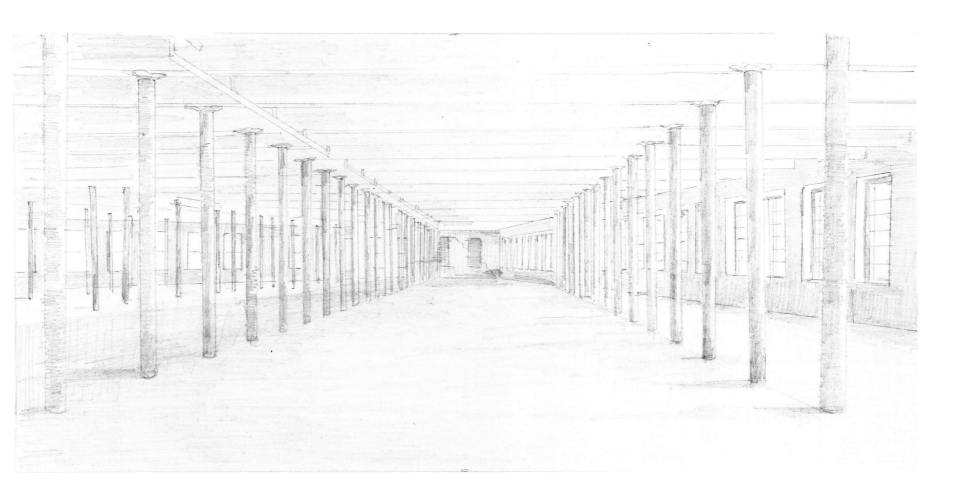

Final composition is decided upon.

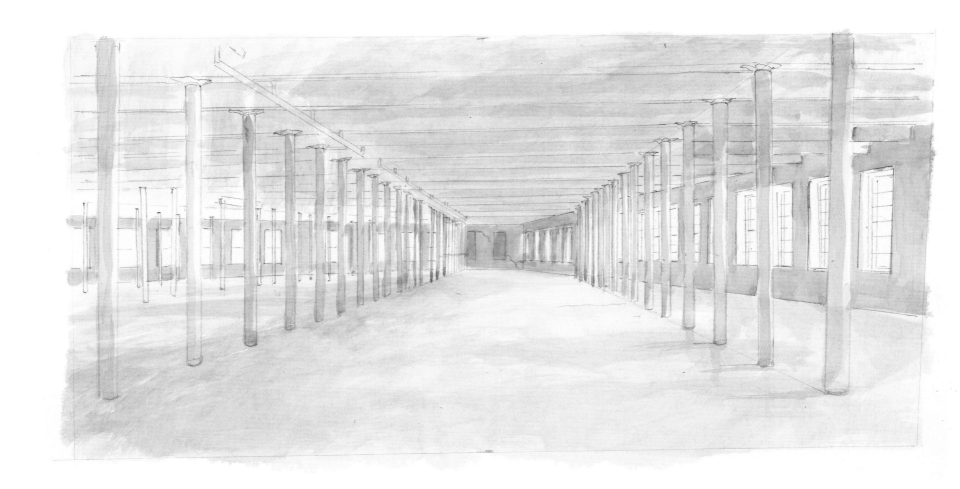

Deciding whether a warm wash is the best way to establish the space.

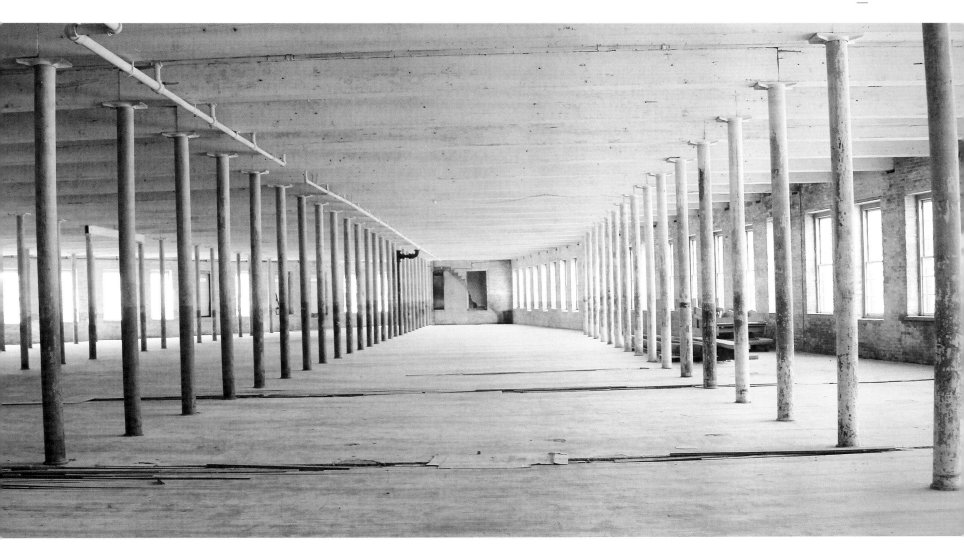

The original space under renovation.

COLOR STUDIES

After the pencil drawings Prey moved to color studies. They began small as she worked out the various saturations of the colors, experimenting with different weights of watercolor paper to find one with just the right properties. Once she settled on a paper type she moved to larger studies. The last study undertaken was 32" x 40" – well-sized piece in its own right – which was tacked up on the wall as a reference for the final painting.

"My work is often about memory and much is done on site/plein air but I make changes, move things around and create a very different interpretation and painting of what the subject might be. Because with my earlier pencil studies I'd achieved an accurate framework of the overlying mill space, I now really had the freedom with my color studies to explore the sense of feel I was trying to evoke and convey within the larger piece as a whole."

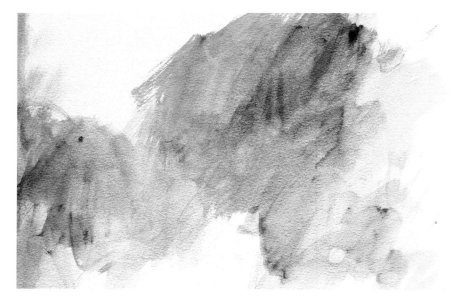

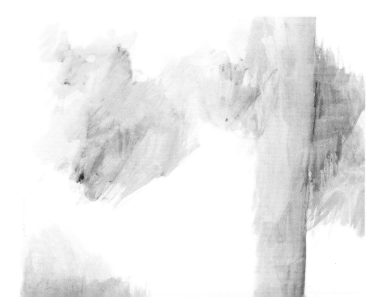

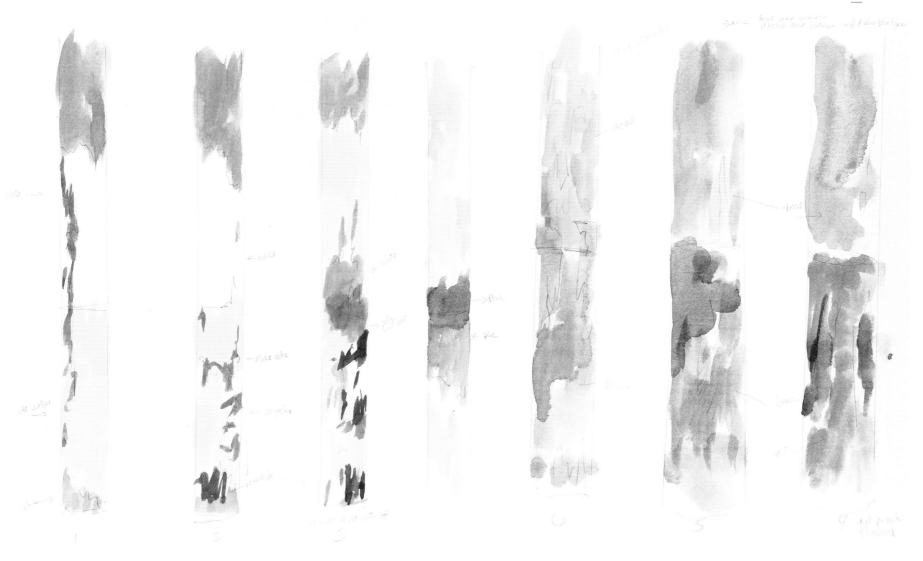

Column color studies with notes.

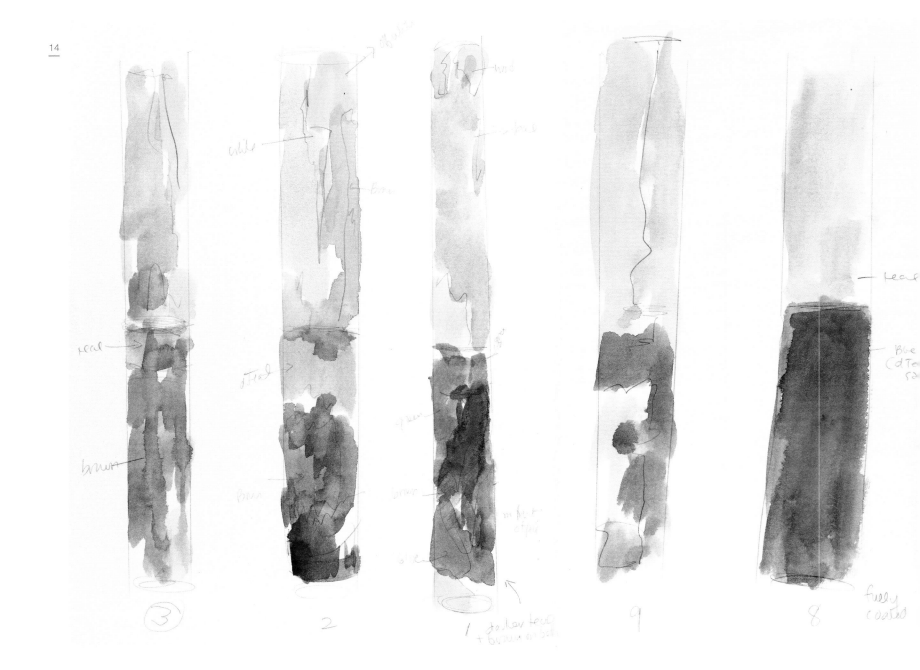

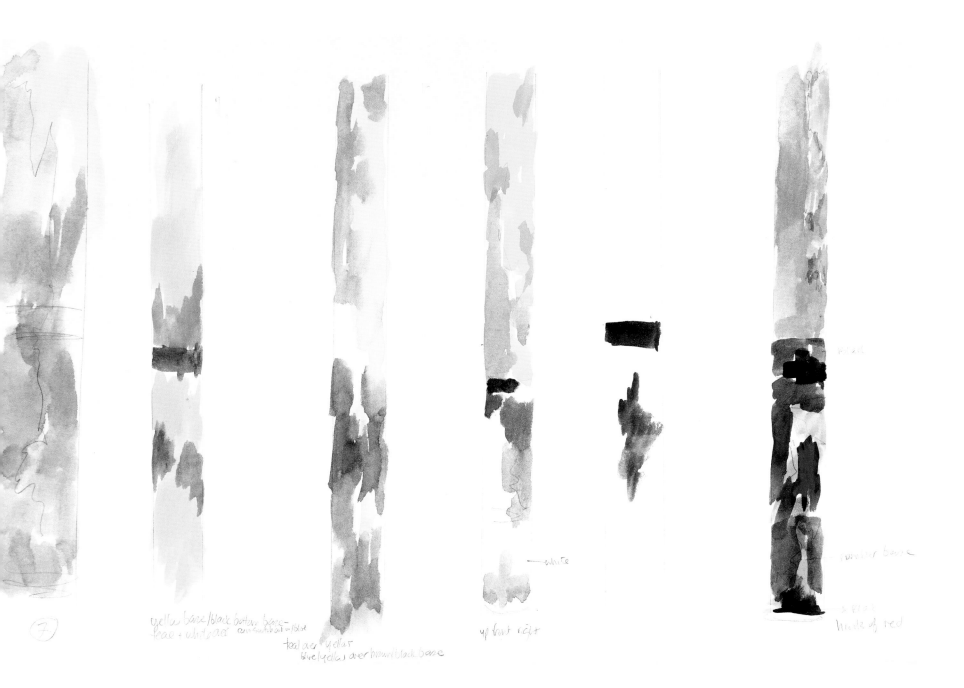

Column color studies with notes.

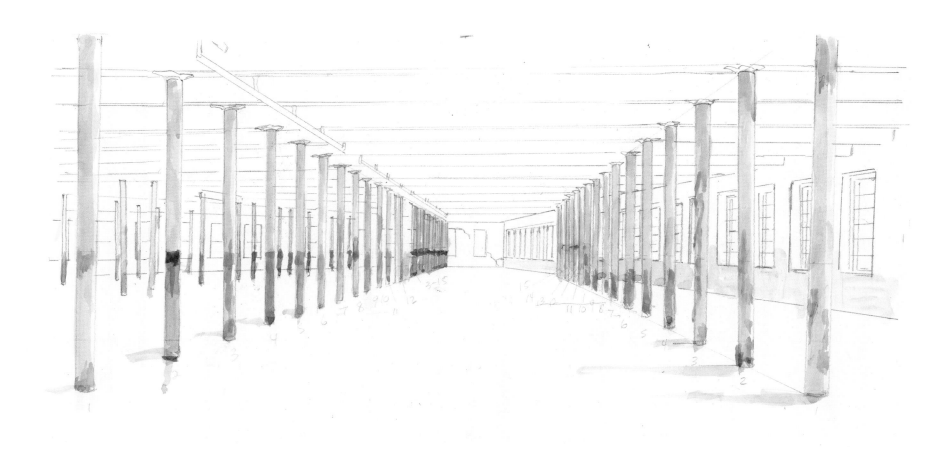

Column color study with full space and point of view, numbers on the
bottom correspond to column studies.

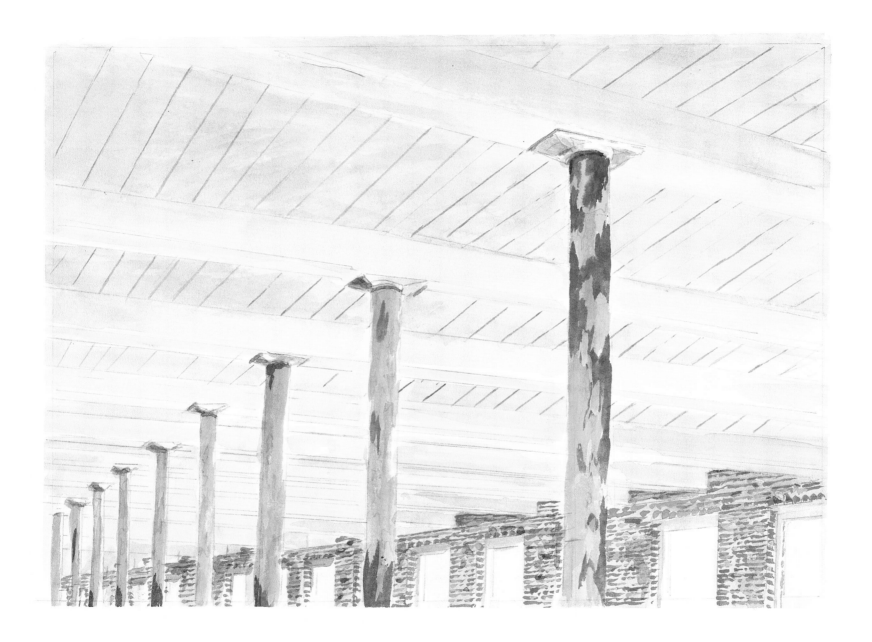

Ceiling study to work out angles of the room.

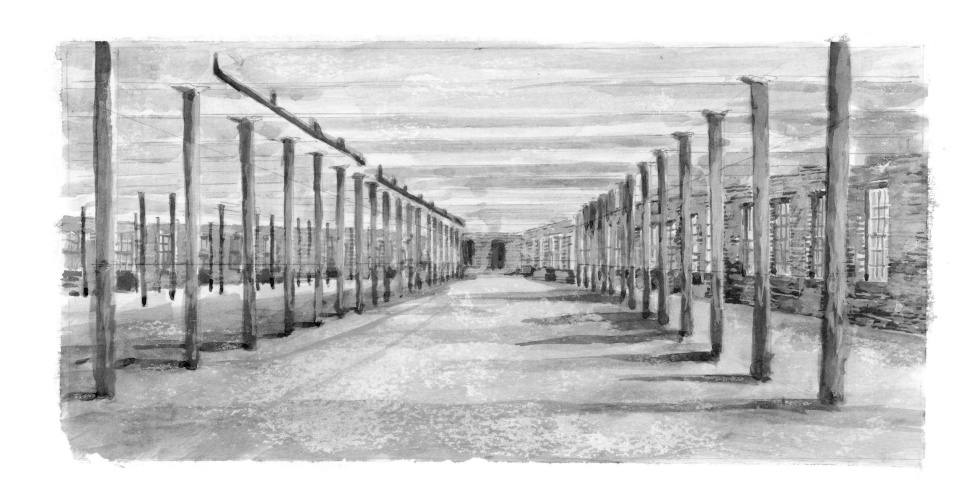

First color studies. Seeing the way different saturations of light fill the space.

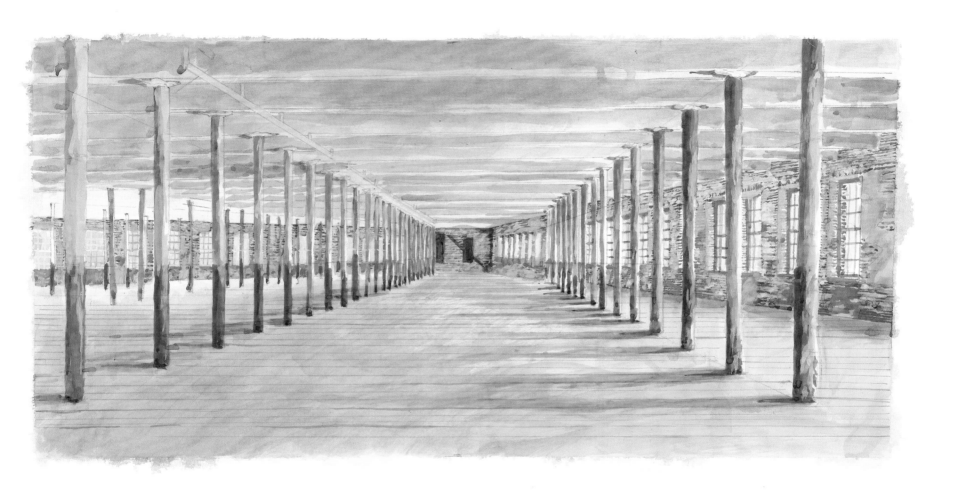

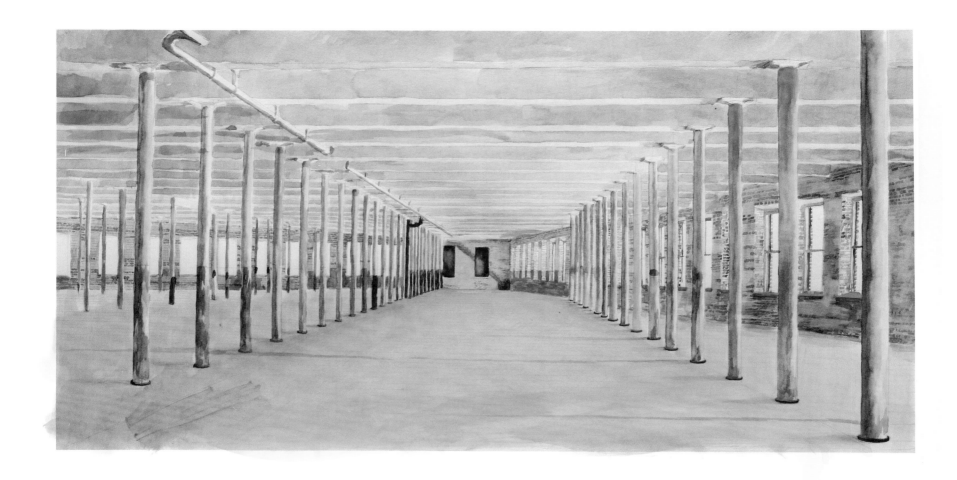

A change of palette and experimenting with cooler washes.

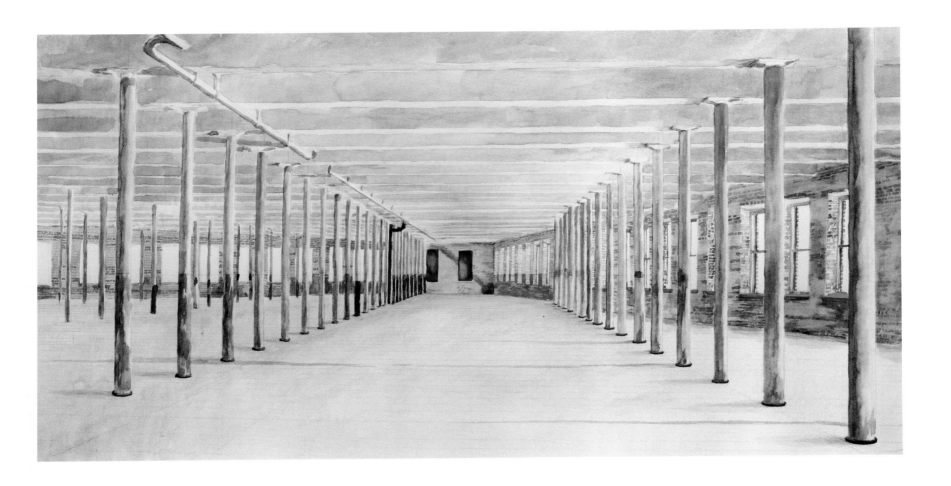

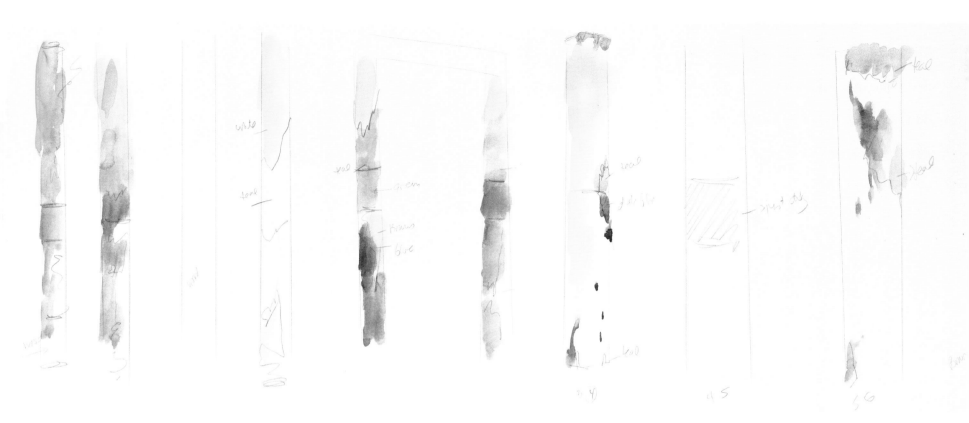

Color studies juxtaposed with their respective columns in the finished piece.

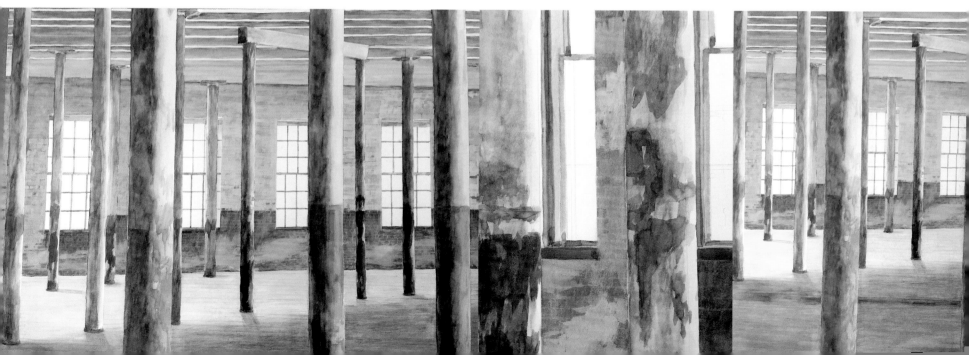

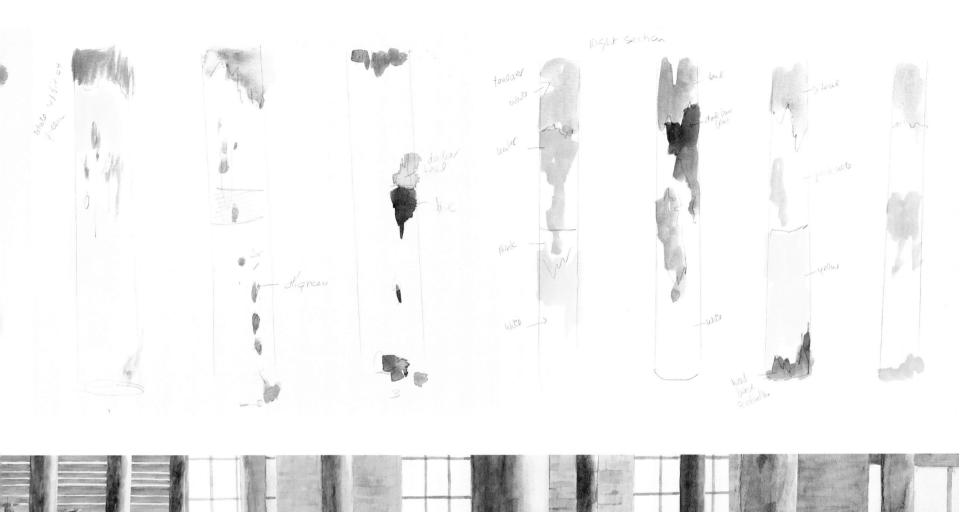

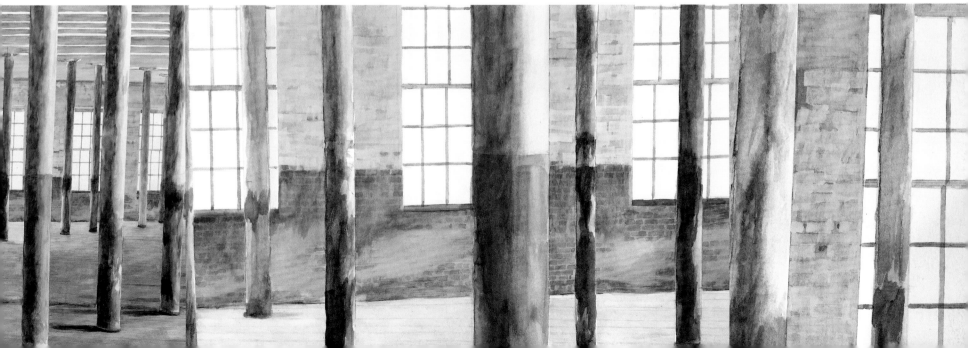

MATERIALS AND CREATION

Curators contacted at MOMA and The National Gallery of Art weren't aware of a watercolor painting equal or comparable to the final size of Prey's work, 8 by 15 feet, making finding materials a challenge. The idea of the largest watercolor in the world, or the largest work by a living female artist sounds exciting but the process to even get to the beginning point was a zigzag of different trials and errors. From the outset, just finding watercolor paper so large proved to be a challenge. Eventually, Prey and the museum found an excellent supplier who provided three aluminum-backed watercolor paper panels that were joined together, creating a seamless and innovative surface for the piece.

Next up was to figure out how to build the supports so that it would be possible to paint the watercolor without the paint dripping down the front of the painting, which it would do if it was placed vertically. This took a bit of engineering to figure out. The supports needed to be flush and exact as there are many columns, windows and architectural details in the painting whose lines needed to align across the three panels. Watercolor is one of the most unforgiving mediums, and even the smallest error would reverberate with outsize effect across the entire piece.

The next challenge was how to transfer Prey's preliminary drawings onto the very large surface. She needed enough space so that she could step back and view the drawing in progress for final corrections and overall development. She had no idea how long the pencil drawing would take, and, as it turned out, it took well over two months to finish. She had to be very cautious with the watercolor paper because any damage to the surface, for example excessive erasing, would have created an area where pigment could puddle, affecting the finished watercolor.

"I spent a lot of time researching the brushes that would be most appropriate to use for the painting. As there is so much surface space, if I used my usual smaller watercolor brushes the painting would take forever. I settled on some large Japanese brushes and ordered new brushes that I had never used before, hoping they would prove to be good and easy to handle. They ended up being perfect. I used a ladder, a stepstool and homemade scaffolding so that I could get up high on the painting to paint. From the start, this was all about exploring uncharted territory but perhaps the most important thing to remember was that I really couldn't make a mistake."

Trying out different color variations for the windows

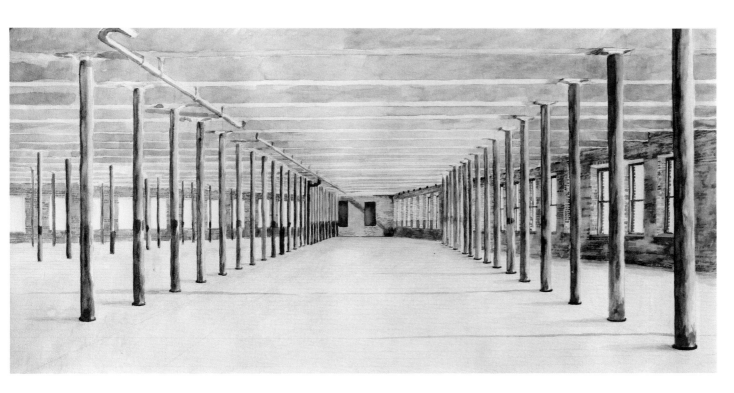

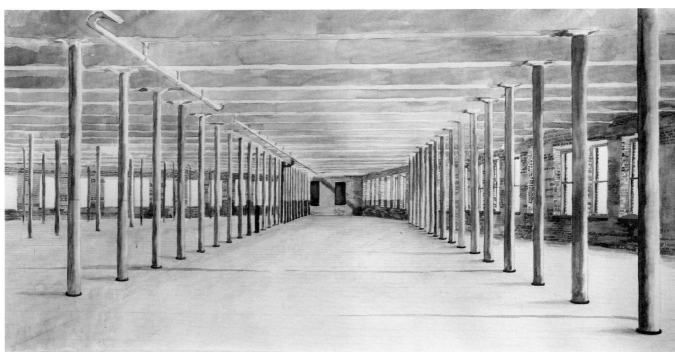

Later color studies experimenting with tint and gradations of wash. Shadow definition and weight have been decided.

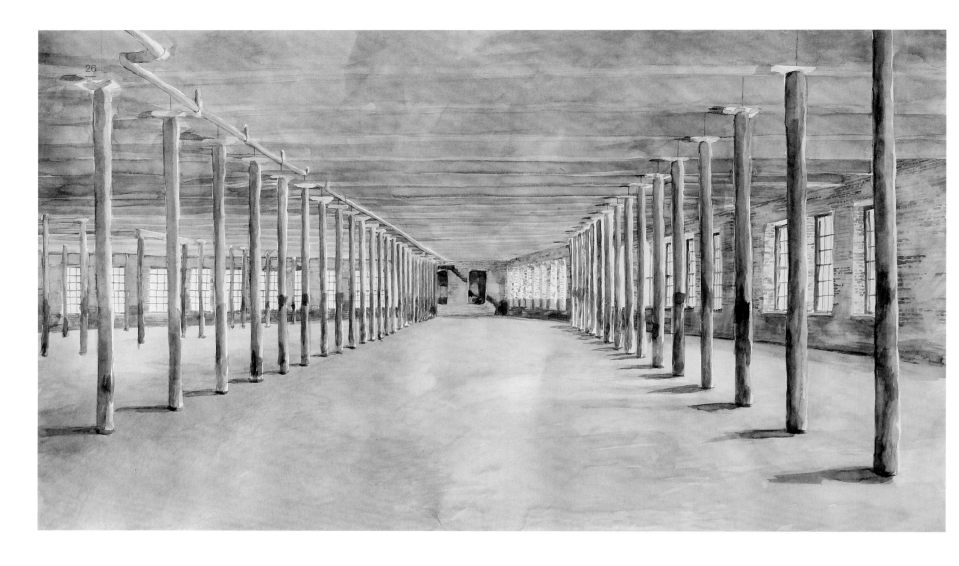

MOVING THE PAINTING TO WILLIAMSTOWN

Although Prey had a large space to work on the painting in New York, it didn't get much natural light and so she made the decision to move the painting to her studio in Williamstown, Massachusetts. This also allowed her to make frequent trips to MASS MoCA, just 4 miles away, to double check Building 6 while she was working.

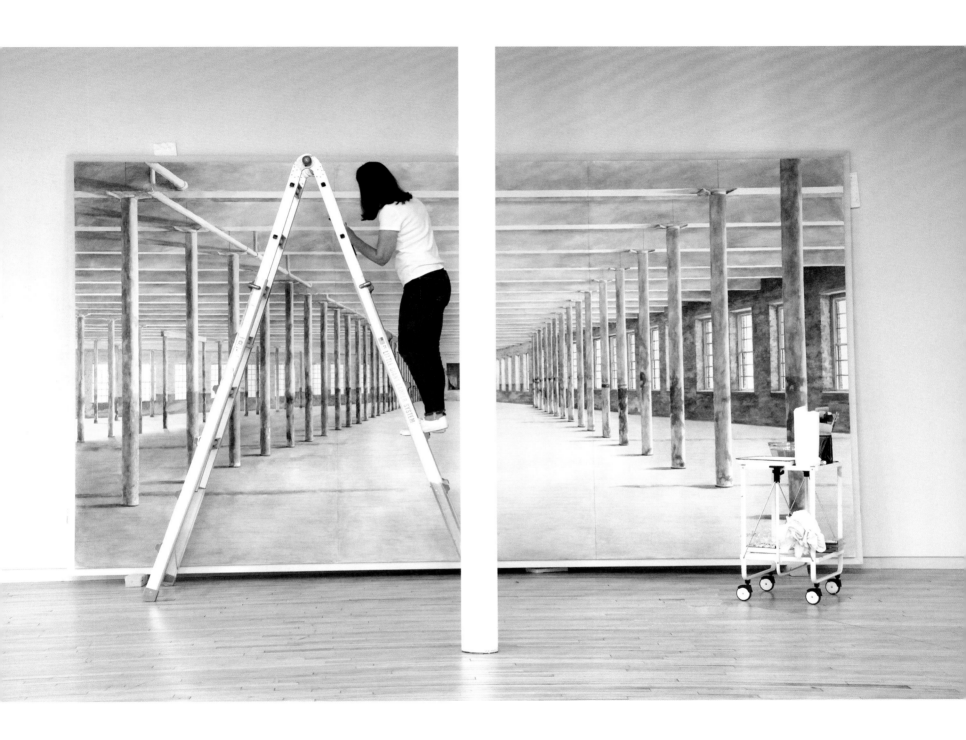

Finishing touches on the final painting on site at MASS MoCA.

BEGINNING (AND CONTINUING) TO PAINT

"After months of preparation and thinking about the project, I have to admit there was a sense of fear when looking at the unforgiving 8 x 5 feet sheet of blank watercolor paper. But I was also excited. With no studio assistants to help, the entire piece would be done by my own hand—every compositional challenge something I alone had to solve."

Watercolor is one of the most difficult painterly mediums to master – it dries quickly, creating hard edges that once set are impossible to paint over or erase. Prey was chosen for the commission because of her rare skill and ability within the medium. Still, even for a living master keeping alive that vibrancy, maintaining fluidity and flexibility given the sheer size of the commission – the largest in the world at 8 x 15 feet unframed – presented a daunting challenge.

"It was a test of my artistic abilities to strike a balance between finishing the discrete parts of the work while keeping constantly moving forward toward a unity of the piece as a whole. I didn't want the element I was currently working on to dry but to flow into the next before it was finished. Especially with a work of this scale, if I weren't able to capture the structure correctly, and all at once, the scale would render everything flat and uninteresting. I had to give the space its own life and the painting's details are an immediate responses to the subject. A lot of energy and movement, creating a sort of abstraction, was involved in painting such a large painting."

Detail from painting.

The finished commission has many layers of color and washes with marks and shifts visible in the underpainting, much of which were kept through to the final work. The original view of the mill space when Prey began the commission was quite raw, covered in dust, the windows full of light, and it was important to give that sense in the painting. The building's interior was continually repainted over the years by its tenants which left many years of peeling colors over the bricks and columns. Sprague Electric had even employed a full time painter to re-coat the space. As the renovation progressed, these layered details started to disappear. Prey's initial color studies, each column given its own respective number and palette, allowed her to get as much information as possible from the original interior before it disappeared completely. Because she had moved the painting to her Williamstown studio, she was able to make trips back and forth to MASS MoCA. Her commission acts as a witness to the historic space.

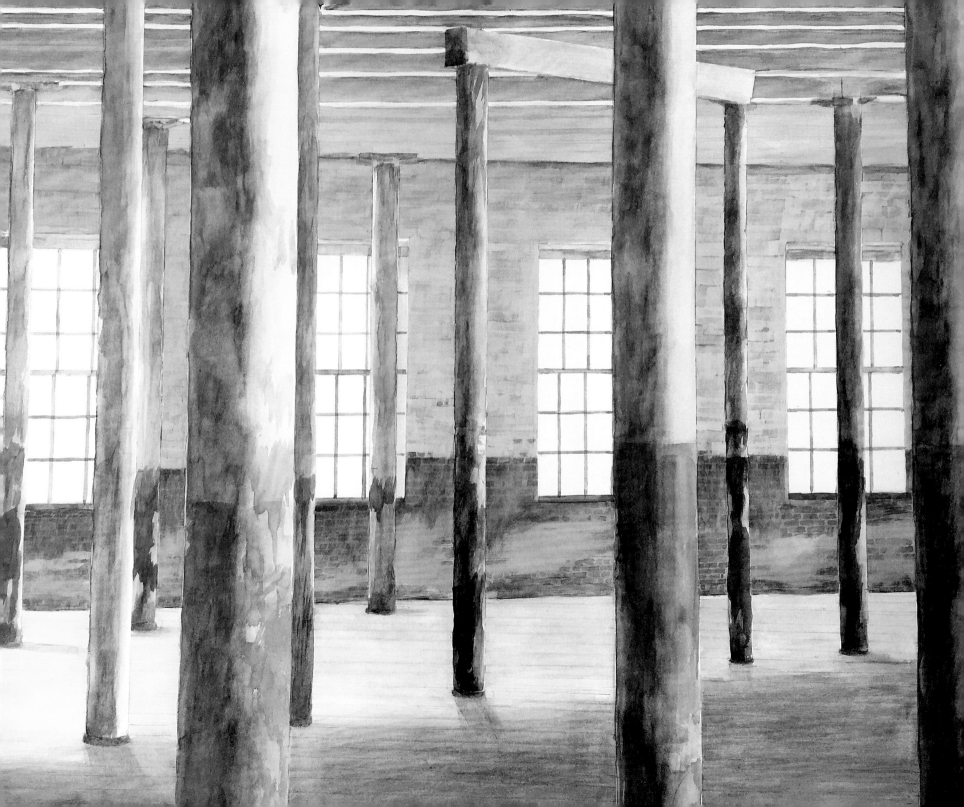

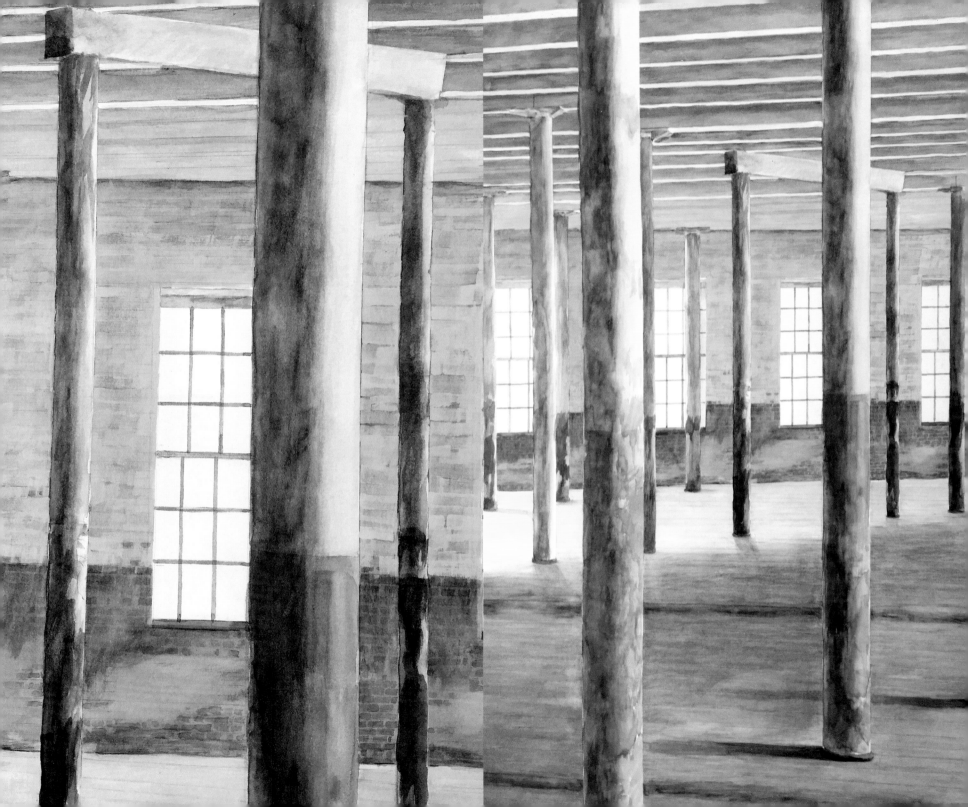

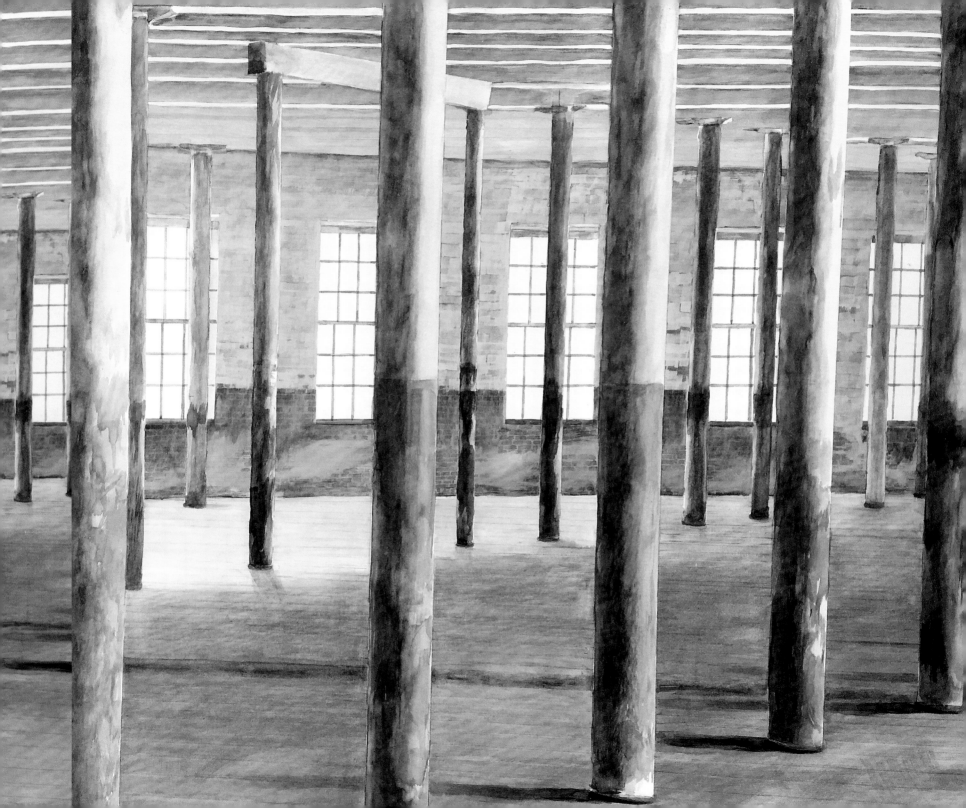

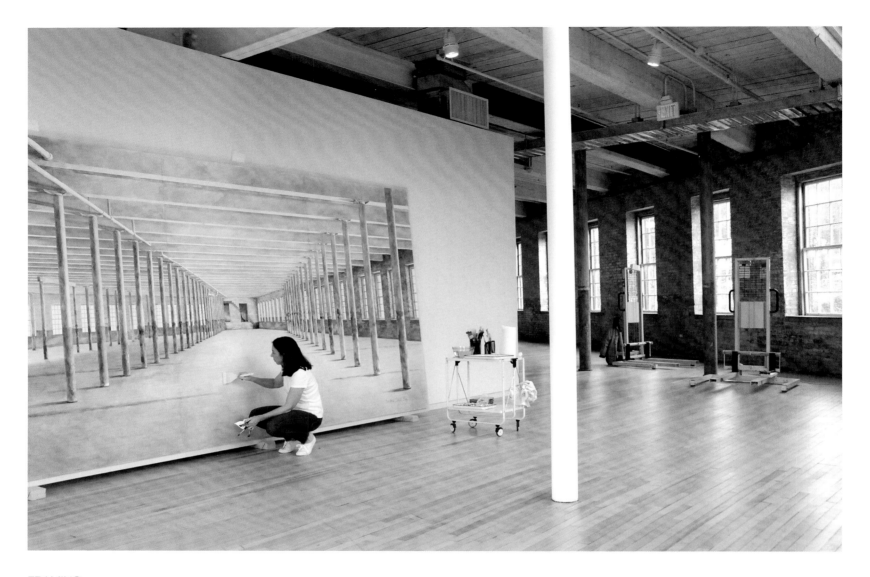

FRAMING

Final assembly of Prey's commission took place at the museum, with the frame being assembled in-house by the Williamstown Conservation Lab (WACC). Much thought went into finding a framer and figuring out the best way to frame such a large work. The finished painting is the largest watercolor in the world. It weighs over 300 pounds, and took seven people to install.

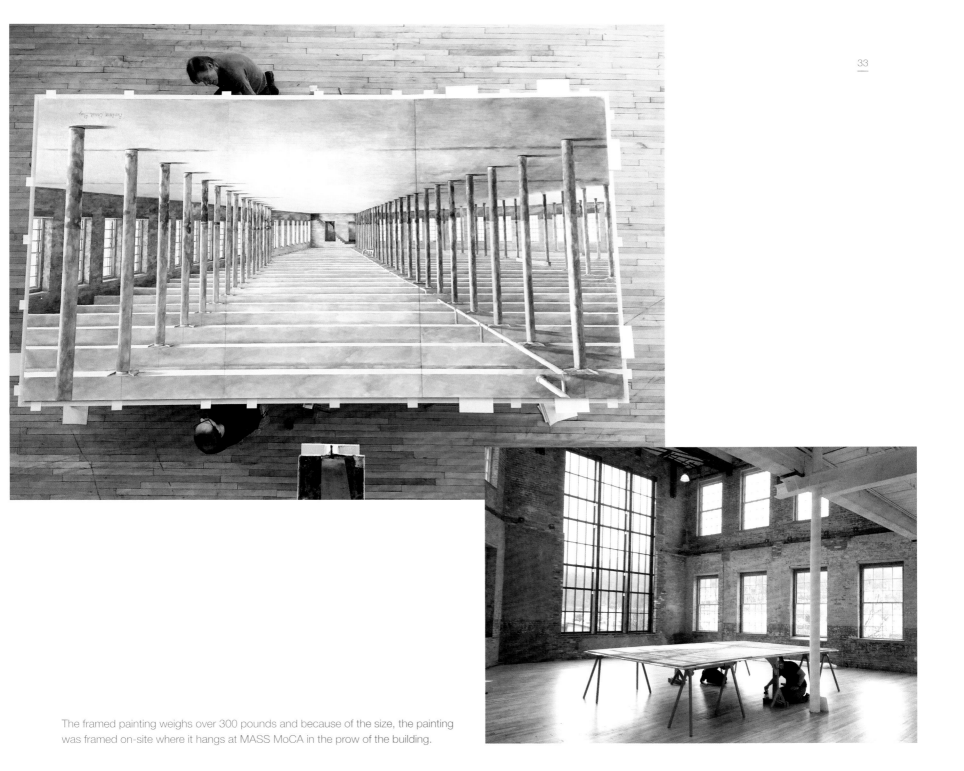

The framed painting weighs over 300 pounds and because of the size, the painting was framed on-site where it hangs at MASS MoCA in the prow of the building.

MASS MoCA just unveiled Building 6, a massive addition of 130,000 square feet of exhibition space, and to inaugurate the new wing, more than a dozen exhibitions by a powerful array of blue chip artists are on display, one of which is something of a meta-show. Barbara Ernst Prey's Building 6 Portrait: Interior consists of a singular work—a giant, framed, 8 x 15 feet watercolor painting depicting the pre-renovation version of the same space the piece is housed in.

—Andrew Nunes via VICE Creators

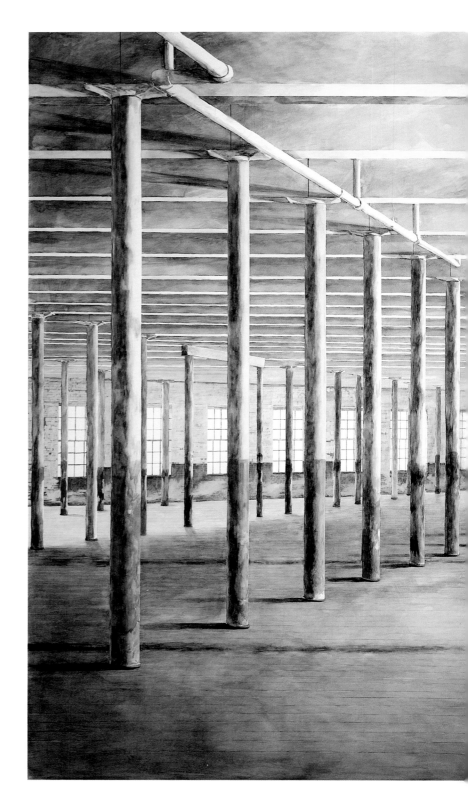

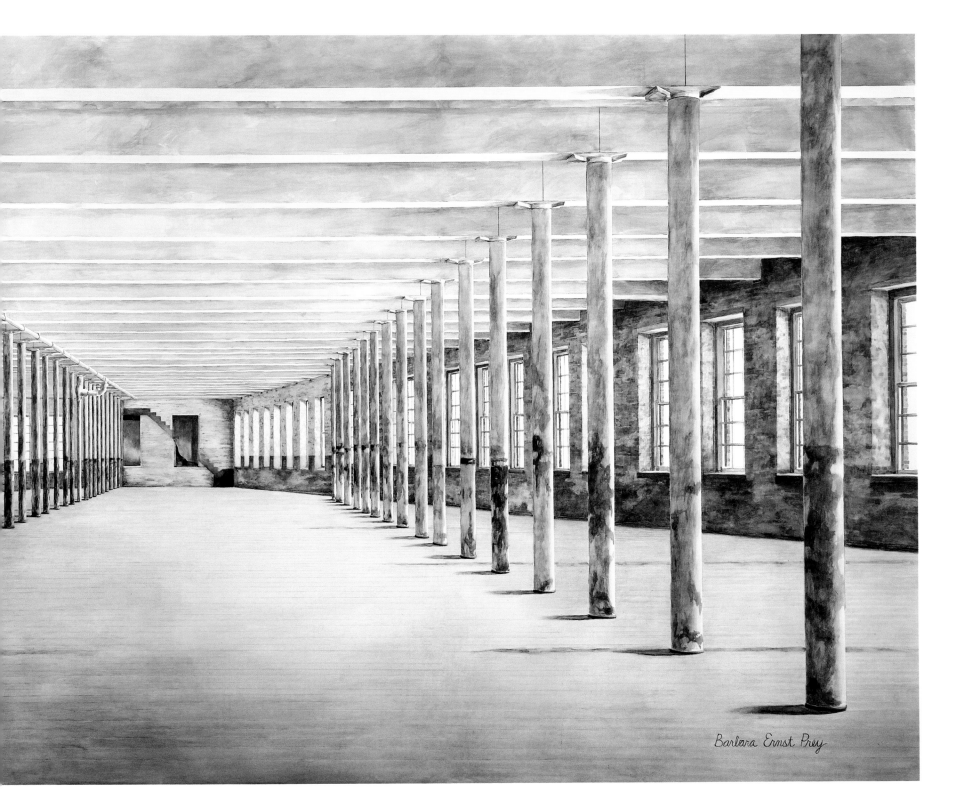

Barbara Ernst Prey

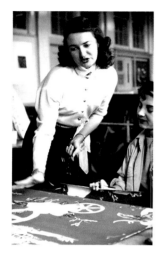

Chronology

1957
Born, New York City. Mother Peggy Ernst artist and head of Design Department at Pratt Art Institute.

1974
Awarded a summer scholarship to the San Francisco Art Institute, CA
Begins to paint watercolors

1975
Lives and paints in Bötersen, Germany
Attends Williams College, Williamstown, MA
Governor Hugh Carey of New York purchases oil painting

1977
Junior Year abroad, University of Munich, Germany

1975-1979
Graduates from Williams College with honors in Art History, mentored by Lane Faison. Graduate courses Clark Art Institute

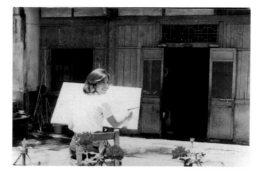

1979
Metropolitan Museum of Art Summer Internship, New York, NY
Fulbright Scholarship University of Würzburg, Germany Baroque Art and Architecture nominated by Williams College
Travels and paints in Europe

1980
Travels and paints in Africa
Personal Assistant Prince Albrecht Castell-Castell, Germany (until 1981)

1981
Castell Bank Exhibition, Germany
Begins illustrations for the New Yorker, New York Times, Gourmet and Good Housekeeping Magazines among others
Works in the Modern Painting Department at Sotheby's in New York, NY

1986
Masters Degree, Harvard University
Teaching Assistant, Harvard University
Marries Jeff Prey

1986-1987
Henry Luce Foundation Grant, Luce Scholar, Visiting Lecturer Western Christian Art, Tainan, Taiwan. Awarded annually to 18 future leaders
Travels and paints in Asia

Exhibitions in Taipei, Taiwan
Starts to paint large-scale on site watercolors
Studies Chinese painting with Master Chinese painter

1987
Returns to U.S. lives and works in Greenwich, CT
First sold out New York City exhibition

1988
Moves to Prosperity, PA (until 1996)

1996
Moves to Oyster Bay, NY

2001
9/11 series

2002
First of four NASA commissioned paintings, *The International Space Station.* NASA commissions contemporary American artists to document space history

2003
Commissioned by United States President and
 Mrs. George Bush to paint the official White
 House Christmas Card
Second NASA commissioned painting, *The
 Columbia Tribute* unveiled at the Columbia
 Anniversary Dinner, Smithsonian National Air
 and Space Museum, Washington DC

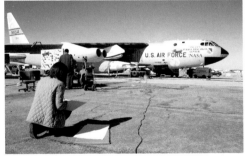

2004
Awarded the New York State Senate's "Women
 of Distinction Award" joining awardees Eleanor
 Roosevelt and Susan B. Anthony
Third NASA commissioned painting, *Shuttle
 Discovery Return to Flight*
Painting *The Diplomatic Reception Room, The
 White House* (2003) enters The White House
 permanent collection. One of two living
 female artists in the White House permanent
 collection

2006
Travels and paints in England

2007
Fourth NASA commissioned painting, the *x-43*.
 Travels to Edwards Airforce Base to paint the
 fastest aircraft in the world.
Travels and paints in Greece, Italy and Croatia

2008
An American View: Barbara Ernst Prey Exhibition,
 The Mona Bismarck Foundation Paris, France
Painting Family Portrait (2004) enters the perma-
 nent collection of The Brooklyn Museum
Painting *Wayfarers* (2002) enters the permanent
 collection of the Smithsonian American Art
 Museum

2008-present
Appointed by the President and approved by the
 Senate to the National Council on the Arts, the
 advisory board to the National Endowment for
 the Arts. Members are appointed for their dis-
 tinguished service or achievement in the arts.

2009
Travels and paints in France

2010
Honoree, The Raynham Hall Museum Gala

2011
Honoree, The Heckscher Museum of Art Gala
Travels and paints in Switzerland and Italy

2012
Travels and paints in the Czech Republic and
 Germany

2013-present
Adjunct Faculty, Williams College, Williamstown,
 MA

2013
Painting *Hydrangeas* enters Bush Presidential
 Library, College Station, TX
Travels and paints in Turks & Caicos and
 Switzerland

2014
Travels and paints in Switzerland, Peru and Israel
Returns to oil painting, continues watercolors
 and drawing

2015
Travels and paints in France and Germany
Appointed to first ever Colonial Williamsburg Art
 Museums Board

2016
Commissioned by *MASS MoCA* to paint the
 world's largest watercolor for the opening of
 their new Building 6
Travels and paints in England, Ireland and
 Switzerland

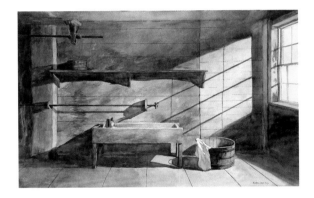

2017
Unveiling of *MASS MoCA* Building 6, 8 feet by 15
 feet, commissioned by the museum
Travels and paints in Scotland and France

2018
Painting *Fibonacci's Workshop* enters the
 National Gallery of Art
Travels and paints in Switzerland and France

2019
Travels and paints in Italy, Martinique, Greece

BARBARA ERNST PREY

Born 1957, New York City, NY
Lives and works in Oyster Bay, NY, Williamstown, MA, and Tenants
 Harbor, ME

Education

1979 B.A., Williams College, Williamstown, MA
1986 M.Div., Harvard University, Cambridge, MA

Affiliations, Awards & Fellowships

2020 Presidential Appointed Member, National Council on the Arts
 (since 2008)
2020 Adjunct Faculty, Williams College, Williamstown, MA (since 2013)
2011 Honoree, Heckscher Museum Gala
2010 Honoree, Raynham Hall Museum Gala
2004 New York State Senate Women of Distinction Award
1986 Henry Luce Foundation Grant, Asia
1979 Fulbright Scholarship, Germany
1974 Grant Recipient, San Francisco Art Institute, San Francisco, CA

Selected Exhibitions:

2020 MASS MoCA, Building 6, Massachusetts Museum of
 Contemporary Art, North Adams, MA *(since 2017)*
 Blue, Nassau County Museum of Art, Roslyn Harbor, NY
 The White House, Washington, D.C. (since 2003)
 Kennedy Space Center, NASA Commission,Titusville, FL
 (since 2003)
 Bush Presidential Library, College Station, TX (since 2013)
 Bush Presidential Library, Office of the First Lady, College
 Station, TX (since 2013)
 National Endowment for the Arts, Office of the Chairman,
 Washington, D.C. (since 2011)
 U.S. Mission to the United Nations, New York, NY (since 2017)
 United States Art in Embassies Program, Bridgetown,
 Barbados (2016-present)

2019 *Borrowed Light: Barbara Ernst Prey*, Hancock Shaker Village,
 Pittsfield, MA
 Energy: The Power of Art, Nassau County Museum of Art,
 Roslyn Harbor, NY
2018 *NASA 60th Art Exhibit*, Space Center, Houston, TX
 True Colors, Nassau County Museum of Art, Roslyn Harbor, NY
 Earth, Sea, Sky, Wendell Gilley Museum, Southwest Harbor, ME
 United States Art in Embassies Program, Baku, Azerbaijan
 (2015-2018)
2017 United Nations, New York, NY (2015-2017)
 Out Painting, Old Westbury Gardens, Old Westbury, NY
2016 *OUT OF THIS WORLD. The Art and Artists of NASA*,
 Vero Beach Museum, Vero Beach, FL
 ON SITE: Barbara Ernst Prey's Travelogues, Barbara Prey
 Projects, Port Clyde, ME
 In Search of America, Barbara Prey Projects, Port Clyde, ME
 United States Art in Embassies Program, Hong Kong
 (2014-2016)
2015 *Re/Viewing the American Landscape,* Blue Water Fine Arts,
 Port Clyde, ME
2014 *Barbara Prey: American Contemporary*, Blue Water Fine Arts,
 Port Clyde, ME
2013 *East Meets West*, Blue Water Fine Arts, Port Clyde, ME
 United States Art in Embassies Program, Bamako, Mali
 (2010-2013)
2012 *NASA|Art: 50 Years of Exploration*, Smithsonian Traveling
 Exhibition (travels to twelve museums) (2008-2012)
 Nocturne IV, Heckscher Museum of Art, Huntington, NY
 America's Artist: Forty Years of Painting, Blue Water Fine Arts,
 Port Clyde, ME
2011 *Open Spaces*, Blue Water Fine Arts, Port Clyde, ME
2010 *Soliloquy: Meditations on the Environment,* Blue Water Fine Arts,
 Port Clyde, ME
2009 United States Art in Embassies Program, U.S. Embassy Paris,
 France (2005-2009)

United States Art in Embassies Program, U.S. Embassy
Madrid, Spain (2005-2009)
25 Years Exhibiting in Maine, Blue Water Fine Arts, Port Clyde, ME

2008 *An American View: Barbara Ernst Prey*, Mona Bismarck
Foundation, Paris, France
Meditations on the Environment, Blue Water Fine Arts,
Port Clyde, ME

2007 *Picturing Long Island*, The Heckscher Museum, Huntington, NY
Works on Water, Water Street Gallery, Seamen's Church
Institute, New York, NY (2006–2007)
From Port Clyde to Paris, Blue Water Fine Arts, Port Clyde, ME
United States Art in Embassies Program, U.S. Embassy
Vilnius, Lithuania (2007 – 2009)

2006 *From Seacoast to Outer Space*, The Williams Club, New York, NY
United States Art in Embassies Program, U.S. Embassy,
Monrovia, Liberia (2003–2006)
United States Art in Embassies Program, U.S. Embassy,
Minsk, Belarus (2003-2006)
United States Art in Embassies Program, U.S. Embassy Oslo,
Norway (2002–2006)
Guild Hall Museum, East Hampton, NY (1999-2006)
30 Years of Painting Maine, Blue Water Fine Arts, Port Clyde, ME
National Arts Club, New York, NY (2003–2006)

2005 *Works on Water*, Blue Water Fine Arts, Port Clyde, ME

2004 *Observations*, Harrison Gallery, Williamstown, MA
Conversations, Blue Water Fine Arts, Port Clyde, ME

2003 *An American Portrait,* Arts Club of Washington D.C.
United States Art in Embassy Program, U.S. Embassy Prague
(2002–2003)
*The Valley Viewed: 150 Years of Artists Exploring
Williamstown,* Harrison Gallery, Williamstown, MA
Painting Reviewed, Blue Water Fine Arts, Port Clyde, ME

2002 *Obsession,* Heckscher Museum of Art, Huntington, NY
American Art in Miniature, Gilcrease Museum, OK (1998–2002)
Patriot, Blue Water Fine Arts, Port Clyde, ME
A Trace in the Mind: An Artists Response to 9/11, Hutchins
Gallery, C.W. Post College, Brookville, NY

2001 *Lightscapes,* Jensen Fine Arts, New York, NY
Recent Watercolors, Blue Water Fine Arts, Port Clyde, ME

1999 *Recent Watercolors,* Jensen Fine Arts, New York, NY
Heckscher Museum, Huntington, NY

1998 *Express Yourself,* Portland Museum of Art, ME

1997 Museum of the Southwest, Midland, TX
Recent Acquisitions, Farnsworth Museum of Art, Rockland, ME

1996 *Best in Show*, The Westmoreland Museum of American Art,
Greensburg, PA

1995 The Philadelphia Museum of Art, Philadelphia, PA

1993 Blair Art Museum, Hollidaysburg, PA
Johnstown Art Museum, Johnstown, PA

1989 *Women's Art,* Williams College Museum of Art, Williamstown, MA

1988 Nassau County Museum of Art, Roslyn Harbor, NY

1986 Harvard University, Cambridge, MA

Selected Public Collections

National Gallery of Art

The White House

The Brooklyn Museum

The Smithsonian American Art Museum

The Massachusetts Museum of Contemporary Art (MASS MoCA)

The Hall Art Foundation

Mellon Hall, Harvard Business School

The Henry Luce Foundation

The Hood Museum, Dartmouth College

The Farnsworth Art Museum

Kennedy Space Center

NASA Headquarters

The National Endowment for the Arts

The Taiwan Museum of Art

The New-York Historical Society Museum

Williams College

The Williams College Museum of Art

Selected Private Collections

Mr. Herbert Allen
Orlando Bloom
Mr. and Mrs. Russell Byers, Jr
Mr. Sam Bronfman
President and Mrs. George W. Bush
Princess Albrecht Castell
Ambassador and Dr. Struan Coleman
Mr. Chris Davis
Mr. and Mrs. Boomer Esiason
Mr. and Mrs. Allan Fulkerson
Senator and Mrs. Judd Gregg
Mr. and Mrs. Tom Hanks
Dr. Franklin Kelly
Prince and Princess Johannes Lobkowicz
Mr. and Mrs. Richard P. Mellon
Mr. Peter O'Neill
Ambassador and Mrs. John Ong
Mr. and Mrs. Howard Phipps, Jr.
Ambassador and Mrs. Mitchell Reiss
Prince and Princess Michael Salm
Ambassador and Mrs. Craig Stapleton
Dr. and Mrs. James Watson
Mr. and Mrs. Jimmy Webb

Selected Commissions

MASS MoCA Commission – 2017
NASA Commission – 2004 Discovery Shuttle Return to Flight
NASA Commission – 2007 The x-43
NASA Commission – 2004 Columbia Tribute
White House Christmas Card, 2003
NASA Commission – 2003 International Space Station

Selected Bibliography

McQuaid, Kate. "A Painter's Eye for Light and Life." *The Boston Globe*, August 28, 2019.

"Barbara Ernst Prey Finds Inspiration in Maine", Interview broadcast on *News Center Maine,* Summer 2018, TV/Video, http://www.barbaraprey.com/news/barbara-ernst-prey-finds-inspiration-in-maine/

Stoilas, Helen. "Despite Uncertainty, US Culture Funding Carries On." *The Art Newspaper,* Dec. 2017, XXVII, No. 296, p.13.

Neuendorf, Henry. "There's Only One Visual Artist on the NEA's Board. Here's What She Thinks of the Imperiled Organization's Future." *artnet.com*, August 16, 2017. Web. https://news.artnet.com/art-world/barbara-prey-interview-1044509

Seven, John. "This Watercolorist Thinks Big." *The Take Magazine*, August 22, 2017. Web. https://thetakemagazine.com/barbara-ernst-prey/

Nalewicki, Jennifer. "The Story behind the World's Largest Known Watercolor Painting." *Smithsonian.com,* June 22, 2017. Web. www.smithsonianmag.com/travel/story-behind-worlds-largest-known-watercolor-painting-180963798/#q8brwIKsM9gCjd4P.99

Nunes, Andrew. "Creators: The World's Largest Watercolor Goes on Display at MASS MoCA." *VICE,* May 2017. Web. https://creators.vice.com/en_us/article/mass-moca-worlds-largest-watercolor

Gay, Malcolm. "MASS MoCA Thinks Big with Latest Expansion." *The Boston Globe*, May 21, 2017. Web. https://www.bostonglobe.com/arts/art/2017/05/20/with-expansion-mass-moca-enters-new-era/1rkr4TX5MX6bAHfEsl58wK/story.html

Vartanian, Hrag. "The World's Largest Watercolor Painting." *Hyperallergic*, May 20, 2017. Web. Hyperallergic.com https://hyperallergic.com/380141/required-reading-321/

Munemo, Julia. "A Physical Connection." *Williams College Website*, May 22, 2017. Web. www.Williams.edu. https://www.williams.edu/feature-stories/a-physical-connection/

Masello, David. "A Colorful Life: Barbara Prey Paints Landscapes that Reflect both an Inner and Outer World." *American Arts Quarterly*, May 2016.

Morgan, Tiernan. "News: Art Movements." *Hyperallergic,* April 10, 2015. Web. https://hyperallergic.com/197396/art-movements-94/

"Three Barbara Ernst Prey Paintings on Exhibit at United Nations." *Bangor Daily News*, December 15, 2015.

Schinto, Jeanne. "Maine is for Art Lovers." Fine Art Connoisseur, August 1, 2015, p. 102–103.

Keyes, Bob. "Barbara Prey Departs Routine, Turns to Oils." *Maine Today: Portland Press Herald*, July 28, 2015.

Russell, Anna. "The Art Gift List.*" The Wall Street Journal,* December 19, 2014, p. D1 (Cover) – D2.

Tyler, Jan. "Painter With a Worldwide Perspective: Barbara Ernst Prey's Artworks have a Global Reach from Embassies to the White House." *Newsday Magazine Cover*, November 1, 2014, p. B4 Cover, B4 – B5.

Rotkiewicz, Jessica. "Painter With a Worldwide Perspective: Barbara Ernst Prey's artworks have a global reach from embassies to the White House." *Newsday,* November 1, 2014. Video.

Down East Magazine Cover, August 2014, 60th Anniversary Issue.

Phelps, Tori. "An American Masterpiece: Barbara Ernst Prey." *Vie Magazine*, July/August 2014.

Serino, Laura. "Five Questions with Artist Barbara Ernst Prey." *Down East Magazine*, July 2014.

Rosen, Raphael. "Chronicling the Space Age in Watercolor: The Work of Barbara Prey." *SciArt in America*, June 2014. Cover.

CBS Television Network, (interview), March 2014.

Kahn, Joseph. "Sales of Prey Prints Benefit Habitat.*"* Names/ Celebrities, *Boston Globe,* December 2013.

Fee, Gayle. "We hear: Artist Barbara Ernst Prey.*" Boston Herald*, December 22, 2013.

"Presidential Greetings: Happy Holidays from the White House." *Parade Magazine*, December 15, 2013.

"Art Works in Progress: Painter Barbara Ernst Prey Finds Wonder in Commonplace." *Maine Public Radio*, (interview), August 22, 2013.

"Prey Love: Pick of the Day.*" The Boston Globe*, August 19, 2013.

Keyes, Bob. "Five Works of Art that Speak to America the Beautiful." *The Portland Herald/Maine Sunday Telegram*, June 27, 2013.

"National Council Art Choices." *The National Endowment for the Arts, Nea.gov.*, July 2012.

"White House Christmas Cards: A Look Back at Some of the Holiday Greetings from The White House." *The Washington Post,* December 14, 2011.

Parks, Steve. "The Heckscher Celebrates Barbara Ernst Prey.*" Newsday,* November 18, 2011.

"Prey Exhibit at Heckscher Museum." The New York Times, December 4, 2011.

CBS Evening News (http://www.cbsnews.com/video/watch/?id=7373526n&tag=content) July 2011.

CBS Sunday Morning (http://www.cbsnews.com/video/watch/?id=7373526n&tag=content) July 2011.

BBC *The Strand* (http://www.bbc.co.uk/programmes/p00hdpxh) June, 2011

"Nasa|Art: 50 Years." *National Endowment for the Arts*, June 11, 2011. Web. http://nea.gov/artworks/

Voice of America, June 2011.

Triplett, William. "Space, the Artistic Frontier.*" The Wall Street Journal*, July 2011.

The Washington Post, July 2011.

"Barbara Ernst Prey." WFAN, (interview), August, 2011.

Aolnews.com, June 2011.

Mendelsohn, Janet. *Maine's Museums: Art, Oddities & Artifacts*. Countryman Press, June 2011. p. 89–92.

"The Artist's Role in the Community.*" National Endowment for the Arts/NEA Arts Magazine*, Spring 2011.

Rooney, Ashley E. *100 Artists of New England*. Schiffer, February 2011, p. 58–59.

Bush, Laura. *Spoken from the Heart*. Simon & Schuster, 2010, p. 298.

"John Singer Sargent's Watercolors.*" The Washington Post,* December 17, 2009.

"Williams Women at the Helm of American Art.*" Williams College Museum of Art*, November/December 2009.

"Maine Watch with Jennifer Rooks." *Maine Public Television*, (interview), July 6, 2009.

"The Maine Event." *RobbReport.com,* July 1, 2009. Web. http://www.robbreport.com/The-Maine-Event.

"Comings and Goings." The Art Newspaper, February 2009.

"Arts Healing Powers." *The Saturday Evening Post*, February 2009, p. 70–72.

"Barbara Ernst Prey Confirmed to National Council on the Arts." *Boston Globe,* January 9, 2009.

"Barbara Ernst Prey Confirmed to Serve on National Council on the Arts." ArtDaily.org, January 9, 2009.

"Barbara Prey to Serve on National Council on the Arts." *Chicago Tribune*, January 9, 2009.

"Maine Artist Named to National Post." *AP Newswire*, January 7, 2009.

"Portrait of Speed." Newsday, January 4, 2009.

"Artist Barbara Prey to Serve on National Council on the Arts." *Artforum*, December 29, 2008.

Abrams, Harry. *NASA|ART: 50 Years*, Abrams Books, 2008.

Heller, Steven. "NASA|Art: 50 Years." *The New York Times Book Review,* December 21, 2008, p. 35.

USA Today.com, December 21, 2008.

"Where a Painter Travels for a Visual Feast." *More Magazine*, May 2008.

Cash, Sarah. *An American View: Barbara Ernst Prey*. Exhibition Catalogue. The Mona Bismarck Foundation, Paris 2007.

Barbara Ernst Prey – An American View, BeauxArts, November 2007.

Thivard, Elodie. "Vision Americaine." *Artistes Magazine*, January/February 2008.

"Barbara Ernst Prey." *Détente Jardin,* January/February 2008.

"An American View." *L'Ami des Jardins et de la Maison*, January 2008.

"An American View." *Relaxfil Evenements*, January 4, 2008.

"An American View." *Maisons Cote Ouest,* December/January 2008.

"Time Off – Museum Exhibitions Europe: An American View: Barbara Ernst Prey." *The Wall Street Journal*, December 2, 2007 (Paris selection).

"Aquarelles d'Amerique." *Mon Jardin et ma Maison*, December 2007.

"An American View." *L'Ami des Jardins et de la Maison*, December 2007.

"Fausse Tranquillite." *Le Journal de la Maison,* December 2007.

"An American View." *Beaux-arts Magazine*, December 2007.

"An American View." *Grands Reportages*, December 2007.

"An American View." *Azart*, November/December 2007.

"An American View: Barbara Ernst Prey." *Paris Capitale*, November 2007.

"Le Maine en aquarelles." *Journal du Dimanche Paris*, November 18, 2007.

"An American View." *20 Minutes*, November 6, 2007.

Tallot, Chloe. "An American View." *Paris Capitale,* November 2007.

"An American View." *Beaux-arts Magazine*, November 2007.

"An American View in Paris." *Women's Wear Daily,* October 26, 2007.

"A Breath of Fresh Air: Painting Nature Now." *Fine Art Connoisseur*, October 2007.

WOR Morning Show with Donna Hanover, (interview), New York, August 2007.

"Dazzled from Port Clyde to Paris." *USA Today Magazine*, July, 2007, p. 38–43, Cover.

Reinert, Patty. "Brush with History." *Houston Chronicle Zest Magazine*, April 15, 2007.

"Nature in an Untouched State." *The New York Times,* February 18, 2007.

"Visions of Long Island." *Newsday*, February 1, 2007.

"High Art." *Harvard Magazine*, November/December, 2006.

"So Watery, the Works of Barbara Ernst Prey." *The New York Sun,* October 25, 2006.

"Time Off - Exhibit: Works on Water." *The Wall Street Journal*, October 19, 2006.

"Barbara Ernst Prey in New York." *PBS WLIW*, (interview), October 2006.

"The Critic's Choice." *The New York Daily News,* October 2006.

"1010 Wins Radio New York with Joe Montone." (interview), October, 2006.

Lieberman, Paul. "Barbara Ernst Prey: Reflections." *Los Angeles Times*, 2006.

"Museums." *The Washington Post,* December 16, 2005.

Cash, Sarah. "Barbara Ernst Prey: Works on Water." In *Works on Water*, 2005.

"Names and Faces: An Artist Ready for Liftoff." *The Washington Post,* July 22, 2005.

National Public Radio, July 2005.

"An Artist on a Space Mission." *Newsday*, July 17, 2005.

"Capturing the Moment." *Florida Today*, July 13, 2005.

"Footlights: Artist Shooting for the Stars." *The New York Times*, July 10, 2005.

"On the Town." *The New York Sun,* April 15–17, 2005.

"2005 Women of Distinction." *Distinction Magazine*, March 2005.

"Barbara Ernst Prey." *PBS WLIW*, (interview), 2005.

The Morning Show, December 4, 2004.

Voice of America, (interview), December 4, 2004.

"Painter Seeing a Bigger Picture." *Los Angeles Times*, October 4, 2004.

Los Angeles Times, October 4, 2004.Web. calendarlive.com

"Prey Exhibit in Maine." *Coastal Living Magazine*, Summer 2004.

"An Artist Review." *Coastal Living*, Currents, July–August, 2004.

CNN News with Carol Lin, (interview), February 2, 2004.

CNN Newssource, (interview), February 1, 2004.

NPR, (interview), February, 2004.

"Tribute Reflects the Lives of Columbia Crew." *Newsday,* February 1, 2004.

1010 Wins Radio New York with Joe Montone, (interview), February 1, 2004.

WOR The Ed Walsh Show, (interview), February 1, 2004.

CBS News Radio, (interview), February 1, 2004.

"The Fine Art of the Space Age." The Washington Post, January 26, 2004.

"Artist Fulfills New Mission for NASA." *AP Newswire*, January 26, 2004.

"Artist Reaches New Heights." *The Boston Globe*, January 20, 2004.

"Talk of the Town." *The New Yorker*, December 1, 2003.

"She Answered a Call from Washington." *The New York Times*, December 21, 2003.

"Paula Zahn NOW." *CNN*, (interview), December 23, 2003.

"Larry King Live." *CNN*, December 2003.

HGTV White House Christmas Special, (interview), December, 2003.

"Ticket." *PBS WLIW*, (interview), December 2003.

The Robb Report, August 2003, September 2003.

Arts and Antiques Magazine, Summer 2003.

"Public Lives: Painting a Still Life That Moves at 17,000 M.P.H." *The New York Times*, October 31, 2002.

"On the Loose in New York." The International Art Newspaper, April 2001.

Stasi, Linda. "Famous Last Word." *The New York Post*, April 22, 2001.

"The Critic's Choice." *The New York Daily News*, April, 2001.

Art and Antiques Magazine, April 2001.

"A List." *Avenue Magazine*, April 2001.

"True North: Barbara Ernst Prey Inspiration." *Maine PBS*, 2001.

"Barbara Ernst Prey." *American Artist Magazine, Watercolor,* 2001.

Town and Country Magazine, August 2000.

"Where Artists Live Their Work Comes Alive." *Newsday, Annual Home Magazine Issue*, Cover, 1999.

"The Metro Report." *PBS- Channel 21*, New York, June 1999.

"The Critic's Choice." *The New York Daily News*, January 1999.

"Art Market." *The International Art Newspaper*, January 1999.

"Parties/Previews." *Country Plaza Magazine*, May/June 1990.

"Tastemakers." *Art World Magazine*, February 1988.

"Taiwan Pictured Through Western Eyes." *Asia Magazine*, July 1987.

U.S. Painter Views Taiwan With Color and Contrast, China Post, May 1987.

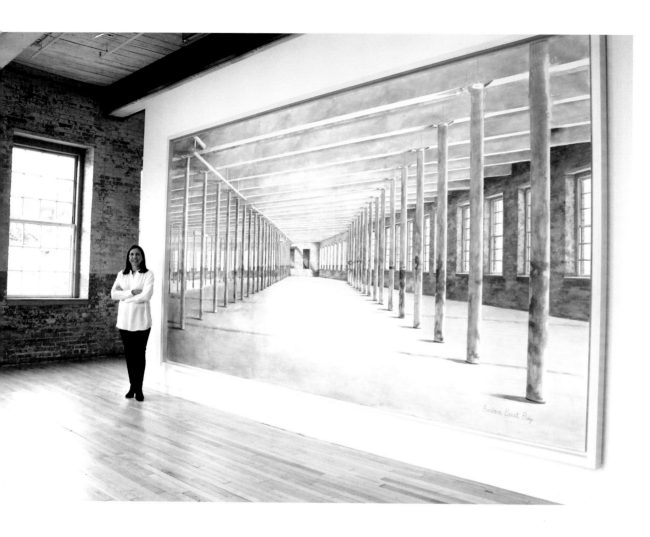

Thank you to MASS MoCA Director Joe Thompson for this commission and taking on the project, as well as the incredible staff at MASS MOCA who helped make it happen.

Thank you to Jeff, Austin and Emily for their insights and expertise which were invaluable in bringing this project to fruition.

Editor: Austin Prey

Artworks by Barbara Ernst Prey © Barbara Ernst Prey

Design: HHA design, Hannah Alderfer

ISBN: 978-0-9964740-3-0

Library of Congress Control Number: 2019919207

Printed in Canada